# Wildlife **Photographer** of the Year Diary 2016

Published by the Natural History Museum, London

The award-winning pictures gathered in this diary have been drawn from the archives of the Wildlife Photographer of the Year competition – the international showcase for the very best nature photography. The competition is owned by the Natural History Museum, London, which prides itself on revealing and championing the diversity of life on Earth.

Wildlife Photographer of the Year is one of the most popular of the Museum's exhibitions. Visitors come not only to see breathtaking imagery, but also to understand some of the threats faced by our planet's animals and plants. Understanding and finding ways of conserving the Earth's biodiversity is at the heart of the Museum's work. This exhibition is one way to share that mission with others, encouraging us to see the environment around us with new eyes.

The Natural History Museum looks after a world-class collection of over 80 million specimens. It is also a leading scientific research institution, with ground-breaking projects in more than 68 countries. About 200 scientists work at the Museum, researching the valuable collections to better understand life on Earth. Every year more than five million visitors, of all ages and levels of interest, are welcomed through the Museum's doors.

## 2016

**JANUARY**
| wk | M | T | W | Th | F | S | S |
|---|---|---|---|---|---|---|---|
| 1 |  |  |  |  | 1 | 2 | 3 |
| 2 | 4 | 5 | 6 | 7 | 8 | 9 | 10 |
| 3 | 11 | 12 | 13 | 14 | 15 | 16 | 17 |
| 4 | 18 | 19 | 20 | 21 | 22 | 23 | 24 |
| 5 | 25 | 26 | 27 | 28 | 29 | 30 | 31 |

**FEBRUARY**
| wk | M | T | W | Th | F | S | S |
|---|---|---|---|---|---|---|---|
| 5 | 1 | 2 | 3 | 4 | 5 | 6 | 7 |
| 7 | 8 | 9 | 10 | 11 | 12 | 13 | 14 |
| 8 | 15 | 16 | 17 | 18 | 19 | 20 | 21 |
| 9 | 22 | 23 | 24 | 25 | 26 | 27 | 28 |
| 10 | 29 |  |  |  |  |  |  |

**MARCH**
| wk | M | T | W | Th | F | S | S |
|---|---|---|---|---|---|---|---|
| 10 |  | 1 | 2 | 3 | 4 | 5 | 6 |
| 11 | 7 | 8 | 9 | 10 | 11 | 12 | 13 |
| 12 | 14 | 15 | 16 | 17 | 18 | 19 | 20 |
| 13 | 21 | 22 | 23 | 24 | 25 | 26 | 27 |
| 14 | 28 | 29 | 30 | 31 |  |  |  |

**APRIL**
| wk | M | T | W | Th | F | S | S |
|---|---|---|---|---|---|---|---|
| 14 |  |  |  |  | 1 | 2 | 3 |
| 15 | 4 | 5 | 6 | 7 | 8 | 9 | 10 |
| 16 | 11 | 12 | 13 | 14 | 15 | 16 | 17 |
| 17 | 18 | 19 | 20 | 21 | 22 | 23 | 24 |
| 18 | 25 | 26 | 27 | 28 | 29 | 30 |  |

**MAY**
| wk | M | T | W | Th | F | S | S |
|---|---|---|---|---|---|---|---|
| 18 |  |  |  |  |  |  | 1 |
| 19 | 2 | 3 | 4 | 5 | 6 | 7 | 8 |
| 20 | 9 | 10 | 11 | 12 | 13 | 14 | 15 |
| 21 | 16 | 17 | 18 | 19 | 20 | 21 | 22 |
| 22 | 23 | 24 | 25 | 26 | 27 | 28 | 29 |
| 23 | 30 | 31 |  |  |  |  |  |

**JUNE**
| wk | M | T | W | Th | F | S | S |
|---|---|---|---|---|---|---|---|
| 23 |  |  | 1 | 2 | 3 | 4 | 5 |
| 24 | 6 | 7 | 8 | 9 | 10 | 11 | 12 |
| 25 | 13 | 14 | 15 | 16 | 17 | 18 | 19 |
| 26 | 20 | 21 | 22 | 23 | 24 | 25 | 26 |
| 27 | 27 | 28 | 29 | 30 |  |  |  |

**JULY**
| wk | M | T | W | Th | F | S | S |
|---|---|---|---|---|---|---|---|
| 27 |  |  |  |  | 1 | 2 | 3 |
| 28 | 4 | 5 | 6 | 7 | 8 | 9 | 10 |
| 29 | 11 | 12 | 13 | 14 | 15 | 16 | 17 |
| 30 | 18 | 19 | 20 | 21 | 22 | 23 | 24 |
| 31 | 25 | 26 | 27 | 28 | 29 | 30 | 31 |

**AUGUST**
| wk | M | T | W | Th | F | S | S |
|---|---|---|---|---|---|---|---|
| 32 | 1 | 2 | 3 | 4 | 5 | 6 | 7 |
| 33 | 8 | 9 | 10 | 11 | 12 | 13 | 14 |
| 34 | 15 | 16 | 17 | 18 | 19 | 20 | 21 |
| 35 | 22 | 23 | 24 | 25 | 26 | 27 | 28 |
| 36 | 29 | 30 | 31 |  |  |  |  |

**SEPTEMBER**
| wk | M | T | W | Th | F | S | S |
|---|---|---|---|---|---|---|---|
| 36 |  |  |  | 1 | 2 | 3 | 4 |
| 37 | 5 | 6 | 7 | 8 | 9 | 10 | 11 |
| 38 | 12 | 13 | 14 | 15 | 16 | 17 | 18 |
| 39 | 19 | 20 | 21 | 22 | 23 | 24 | 25 |
| 40 | 26 | 27 | 28 | 29 | 30 |  |  |

**OCTOBER**
| wk | M | T | W | Th | F | S | S |
|---|---|---|---|---|---|---|---|
| 40 |  |  |  |  |  | 1 | 2 |
| 41 | 3 | 4 | 5 | 6 | 7 | 8 | 9 |
| 42 | 10 | 11 | 12 | 13 | 14 | 15 | 16 |
| 43 | 17 | 18 | 19 | 20 | 21 | 22 | 23 |
| 44 | 24 | 25 | 26 | 27 | 28 | 29 | 30 |
| 45 | 31 |  |  |  |  |  |  |

**NOVEMBER**
| wk | M | T | W | Th | F | S | S |
|---|---|---|---|---|---|---|---|
| 45 |  | 1 | 2 | 3 | 4 | 5 | 6 |
| 46 | 7 | 8 | 9 | 10 | 11 | 12 | 13 |
| 47 | 14 | 15 | 16 | 17 | 18 | 19 | 20 |
| 48 | 21 | 22 | 23 | 24 | 25 | 26 | 27 |
| 49 | 28 | 29 | 30 |  |  |  |  |

**DECEMBER**
| wk | M | T | W | Th | F | S | S |
|---|---|---|---|---|---|---|---|
| 49 |  |  |  | 1 | 2 | 3 | 4 |
| 50 | 5 | 6 | 7 | 8 | 9 | 10 | 11 |
| 51 | 12 | 13 | 14 | 15 | 16 | 17 | 18 |
| 52 | 19 | 20 | 21 | 22 | 23 | 24 | 25 |
| 53 | 26 | 27 | 28 | 29 | 30 | 31 |  |

## 2017

**JANUARY**
| wk | M | T | W | Th | F | S | S |
|---|---|---|---|---|---|---|---|
|  |  |  |  |  |  |  | 1 |
|  | 2 | 3 | 4 | 5 | 6 | 7 | 8 |
|  | 9 | 10 | 11 | 12 | 13 | 14 | 15 |
|  | 16 | 17 | 18 | 19 | 20 | 21 | 22 |
|  | 23 | 24 | 25 | 26 | 27 | 28 | 29 |
|  | 30 | 31 |  |  |  |  |  |

**FEBRUARY**
| wk | M | T | W | Th | F | S | S |
|---|---|---|---|---|---|---|---|
| 5 |  |  | 1 | 2 | 3 | 4 | 5 |
| 6 | 6 | 7 | 8 | 9 | 10 | 11 | 12 |
| 7 | 13 | 14 | 15 | 16 | 17 | 18 | 19 |
| 8 | 20 | 21 | 22 | 23 | 24 | 25 | 26 |
| 9 | 27 | 28 |  |  |  |  |  |

**MARCH**
| wk | M | T | W | Th | F | S | S |
|---|---|---|---|---|---|---|---|
| 9 |  |  | 1 | 2 | 3 | 4 | 5 |
| 10 | 6 | 7 | 8 | 9 | 10 | 11 | 12 |
| 11 | 13 | 14 | 15 | 16 | 17 | 18 | 19 |
| 12 | 20 | 21 | 22 | 23 | 24 | 25 | 26 |
| 13 | 27 | 28 | 29 | 30 | 31 |  |  |

**APRIL**
| wk | M | T | W | Th | F | S | S |
|---|---|---|---|---|---|---|---|
| 13 |  |  |  |  |  | 1 | 2 |
| 14 | 3 | 4 | 5 | 6 | 7 | 8 | 9 |
| 15 | 10 | 11 | 12 | 13 | 14 | 15 | 16 |
| 16 | 17 | 18 | 19 | 20 | 21 | 22 | 23 |
| 17 | 24 | 25 | 26 | 27 | 28 | 29 | 30 |

**MAY**
| wk | M | T | W | Th | F | S | S |
|---|---|---|---|---|---|---|---|
|  | 1 | 2 | 3 | 4 | 5 | 6 | 7 |
|  | 8 | 9 | 10 | 11 | 12 | 13 | 14 |
|  | 15 | 16 | 17 | 18 | 19 | 20 | 21 |
|  | 22 | 23 | 24 | 25 | 26 | 27 | 28 |
|  | 29 | 30 | 31 |  |  |  |  |

**JUNE**
| wk | M | T | W | Th | F | S | S |
|---|---|---|---|---|---|---|---|
| 23 |  |  |  | 1 | 2 | 3 | 4 |
| 24 | 5 | 6 | 7 | 8 | 9 | 10 | 11 |
| 25 | 12 | 13 | 14 | 15 | 16 | 17 | 18 |
| 26 | 19 | 20 | 21 | 22 | 23 | 24 | 25 |
| 27 | 26 | 27 | 28 | 29 | 30 |  |  |

**JULY**
| wk | M | T | W | Th | F | S | S |
|---|---|---|---|---|---|---|---|
| 27 |  |  |  |  |  | 1 | 2 |
| 28 | 3 | 4 | 5 | 6 | 7 | 8 | 9 |
| 29 | 10 | 11 | 12 | 13 | 14 | 15 | 16 |
| 30 | 17 | 18 | 19 | 20 | 21 | 22 | 23 |
| 31 | 24 | 25 | 26 | 27 | 28 | 29 | 30 |
| 32 | 31 |  |  |  |  |  |  |

**AUGUST**
| wk | M | T | W | Th | F | S | S |
|---|---|---|---|---|---|---|---|
| 32 |  | 1 | 2 | 3 | 4 | 5 | 6 |
| 33 | 7 | 8 | 9 | 10 | 11 | 12 | 13 |
| 34 | 14 | 15 | 16 | 17 | 18 | 19 | 20 |
| 35 | 21 | 22 | 23 | 24 | 25 | 26 | 27 |
| 36 | 28 | 29 | 30 | 31 |  |  |  |

**SEPTEMBER**
| wk | M | T | W | Th | F | S | S |
|---|---|---|---|---|---|---|---|
|  |  |  |  |  | 1 | 2 | 3 |
|  | 4 | 5 | 6 | 7 | 8 | 9 | 10 |
|  | 11 | 12 | 13 | 14 | 15 | 16 | 17 |
|  | 18 | 19 | 20 | 21 | 22 | 23 | 24 |
|  | 25 | 26 | 27 | 28 | 29 | 30 |  |

**OCTOBER**
| wk | M | T | W | Th | F | S | S |
|---|---|---|---|---|---|---|---|
| 40 |  |  |  |  |  |  | 1 |
| 41 | 2 | 3 | 4 | 5 | 6 | 7 | 8 |
| 42 | 9 | 10 | 11 | 12 | 13 | 14 | 15 |
| 43 | 16 | 17 | 18 | 19 | 20 | 21 | 22 |
| 44 | 23 | 24 | 25 | 26 | 27 | 28 | 29 |
| 45 | 30 | 31 |  |  |  |  |  |

**NOVEMBER**
| wk | M | T | W | Th | F | S | S |
|---|---|---|---|---|---|---|---|
| 45 |  |  | 1 | 2 | 3 | 4 | 5 |
| 46 | 6 | 7 | 8 | 9 | 10 | 11 | 12 |
| 47 | 13 | 14 | 15 | 16 | 17 | 18 | 19 |
| 48 | 20 | 21 | 22 | 23 | 24 | 25 | 26 |
| 49 | 27 | 28 | 29 | 30 |  |  |  |

**DECEMBER**
| wk | M | T | W | Th | F | S | S |
|---|---|---|---|---|---|---|---|
| 49 |  |  |  |  | 1 | 2 | 3 |
| 50 | 4 | 5 | 6 | 7 | 8 | 9 | 10 |
| 51 | 11 | 12 | 13 | 14 | 15 | 16 | 17 |
| 52 | 18 | 19 | 20 | 21 | 22 | 23 | 24 |
| 53 | 25 | 26 | 27 | 28 | 29 | 30 | 31 |

## December – January

WEEK 1

28 Monday

29 Tuesday

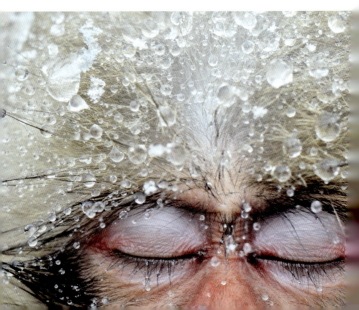

30 Wednesday

31 Thursday
New Year's Eve
Hogmanay (Scotland)

1 Friday
New Year's Day
Holiday (UK, Rep. Ireland, USA, Canada, Australia, New Zealand)

2 Saturday     3 Sunday

**Relaxation**
*by Jasper Doest*
Jasper found about 30 Japanese macaques enjoying a steamy soak in the hot spring pools of Jigokudani Valley, Central Japan. He watched with delight as this youngster became increasingly drowsy. 'It's an honour when an animal trusts you enough to fall asleep in front of you,' says Jasper. 'I used a close-up shot to emphasize the human likeness in both face and pleasure.' This macaque is one of a troop that venture down from their forest habitat on winter days, to warm themselves in the hot springs.

January    WEEK 2

### 4 Monday
Substitute Holiday (Scotland, New Zealand)

### 5 Tuesday

### 6 Wednesday
Epiphany (Christian)

### 7 Thursday

*Today I had to make a choice. Play: War horse with family or George's birthday. I chose...*

**Celebration of a grey day**
*by Fortunato Gatto*
The windswept Isle of Eigg is part of the Small Isles, an archipelago in the Inner Hebrides, formed by volcanic eruptions between 60 and 55 million years ago. Laig Bay is its masterpiece. 'On a stormy day, you get the feeling of having been catapulted into a black-and-white world,' says Fortunato. Bracing himself against the powerful ocean winds, he photographed the textured patterns in the volcanic sands, etched by the ebbing tide. 'To me, it represents the essence of this place.'

8 Friday

9 Saturday

10 Sunday

New moon ●

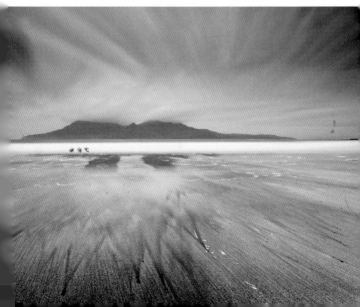

January WEEK 3

11 Monday

12 Tuesday

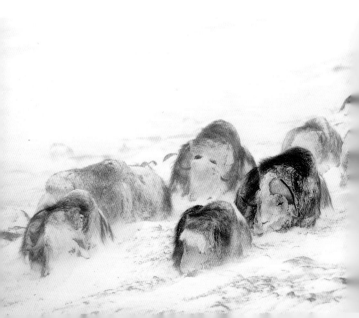

13 Wednesday

14 Thursday

Makar Sankrant (Hindu)

15 Friday

16 Saturday     17 Sunday

**Snowed in**
*by Orsolya Haarberg*
Orsolya camped through winter storms in Norway's Dovrefjell-Sunndalsfjella National Park to photograph muskoxen. On particularly cold days, muskoxen conserve energy by resting. It is then possible to approach them, but if you get too close and spook them, there is a real risk of being trampled. 'For two days,' says Orsolya, 'the wind was so strong and it snowed so much that I couldn't even see the animals.' But the next day it stopped snowing, and the massive forms of muskoxen emerged from the landscape.

January

WEEK 4

18 Monday

Martin Luther King Day, Holiday (USA)

19 Tuesday

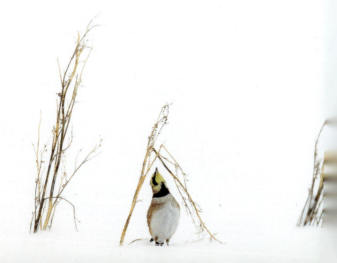

20 Wednesday

21 Thursday

22 Friday

23 Saturday

24 Sunday

Full moon ○

**Tiptoe lark**
*by Henrik Lund*
As Henrik scanned the snow near his home in search of grey partridges, a tiny horned lark, which gets its name from a pair of black feather tufts on the top of its head, ran past searching for food. On finding a few seeds, 'it kept stretching up to try to reach them,' he says, 'jumping if it couldn't.' Using snow as a white backdrop, and the yellow stems as compositional architecture, Henrik managed to capture the lark on tiptoe just before it jumped.

January

WEEK 5

25 Monday

Burns Night (Scotland)

26 Tuesday

Australia Day, Holiday (Australia)

27 Wednesday

Holocaust Memorial Day

28 Thursday

**Mist rising at sunset**
*by Sander Broström*
Sander was photographing at Höje Creek near Knästorp in southern Sweden when great banks of winter mist began to rise up. The sun was setting and he knew he had the chance of a very special shot. 'Luckily I was close to home,' he says, 'because I had time to run back to get my 70–200mm lens. What I really wanted,' says Sander 'was for a bird to fly across the sky.' And then, as though on cue, a cormorant entered from stage left.

29 Friday

30 Saturday    31 Sunday

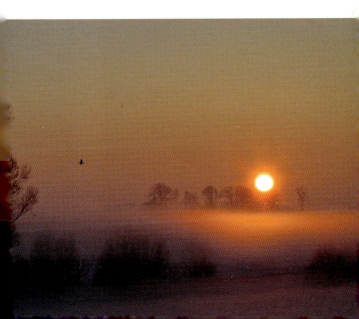

## February

WEEK 6

1 Monday

2 Tuesday

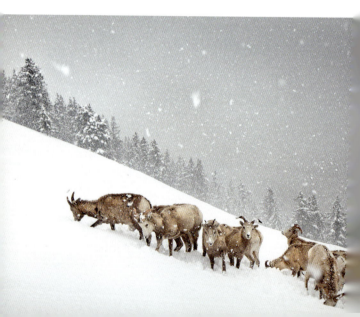

3 Wednesday

4 Thursday

5 Friday

6 Saturday

7 Sunday

**The snow herd**
*by Vladimir Medvedev*
At 1,800 metres (5,905 feet) in the mountains of Canada's Banff National Park, bighorn sheep are forced to scrape into the snow with their hooves to reach the grass below. By using a wide-angle lens Vladimir could show the whole herd in its environment. He worked out which way the herd was heading and then 'walked up the slope and sat right in their path. They saw me, but they weren't bothered,' he says. 'They simply walked around me and continued on their way uphill.'

## February

WEEK 7

### 8 Monday

Chinese New Year (Year of the monkey)
Waitangi Day (New Zealand)
New moon ●

### 9 Tuesday

Shrove Tuesday (Christian)

### 10 Wednesday

Ash Wednesday (Christian)

11 Thursday

12 Friday

13 Saturday

14 Sunday

St Valentine's Day

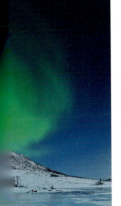

### Aurora over ice
*by Thilo Bubek*
The aurora borealis (or northern lights) takes place when highly charged electrons, thrown out by the sun as solar wind, interact with oxygen and nitrogen in the atmosphere, miles above the surface of Earth. The colour varies depending on which elements are reacting (green is oxygen) and how high up they are. The moon shone high in the sky as Thilo walked out onto the frozen lake. 'Auroras move fast, so I chose a fairly high ISO to capture six images quickly and create a panorama,' says Thilo.

February

WEEK 8

15 Monday
George Washington's Birthday, Holiday (USA)

16 Tuesday

17 Wednesday

18 Thursday

**Bottom view**
*by Michel Roggo*
Michel is passionate about revealing the beauty of freshwater life. In winter, in calm parts of the River Rhine, Switzerland, fish gather in dense groups. 'I'd got an image in my head of a mass of motionless fish,' says Michel, so when a mute swan swam into the frame he was frustrated, but he soon realized that the swan's rear end actually added to the scene. 'I learned that day,' says Michel, 'not to be so single-minded and to embrace all opportunities.'

19 Friday

20 Saturday          21 Sunday

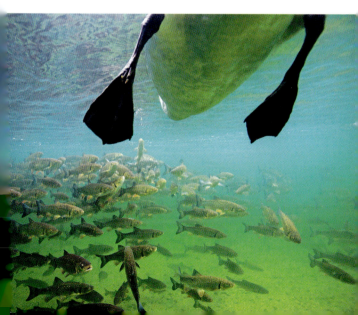

## February

WEEK 9

22 Monday

Full moon ○

23 Tuesday

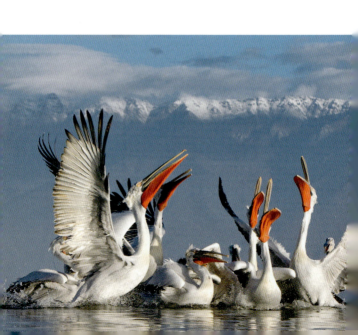

24 Wednesday

25 Thursday

26 Friday

27 Saturday

28 Sunday

**Pelican pack**
*by Jari Peltomäki*
When Jari arrived at Lake Kerkini, many of the Dalmatian pelicans were already in their breeding plumage, the males displaying their orange-red throat pouches. Numbers have declined dramatically, but in winter, hundreds congregate on the lake in northern Greece. 'Local fishermen have a special relationship with them and feed them scraps,' says Jari. 'The pelicans follow the men around, and so I tagged along, too.' He used a floating hide to get the water-level angle he needed as the birds reached skyward for scraps.

February – March                                                                 WEEK 10

29 Monday

1 Tuesday
St David's Day (Wales)

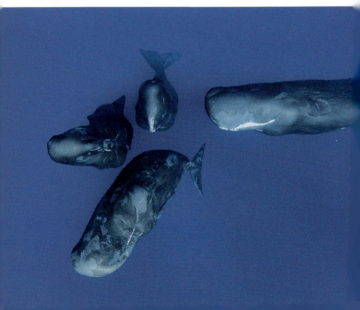

2 Wednesday

3 Thursday

4 Friday

5 Saturday

6 Sunday

Mothering Sunday
(UK, Rep. Ireland)

**The big four**
*by Tony Wu*
Tony spent an unforgettable morning snorkelling above a large group of sperm whales off the Caribbean island of Dominica. 'They spent much of their time at the surface of the ocean, rubbing up against each other, vocalizing and gathering in raft formations – often appearing as if they were playing,' says Tony. These four paused about 10 metres (33 feet) below the surface, and as Tony dived down to have a better look, he could feel their clicking sonar resonating through his body.

# March

WEEK 11

7 Monday

8 Tuesday

9 Wednesday

New moon ●

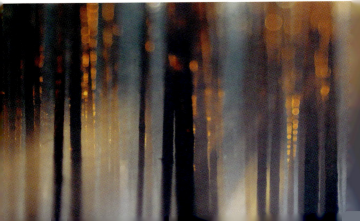

10 Thursday

11 Friday

12 Saturday

13 Sunday

**Light show**
*by Sandra Bartocha*
The fog-wrapped forest was even more beautiful than Sandra had expected. 'The evening sun created a glow around the tall, wet trunks of the Scots pines,' she remembers. 'It was breathtaking.' She experimented with different focal planes and lenses to capture the effect, settling on a tilt lens to create horizontal layers of sharpness. The straight, slender trunks of these pines are the result of dense planting. Competing for light and nutrients, the packed trees grow rapidly up, blocking out the light.

## March

WEEK 12

14 Monday

15 Tuesday

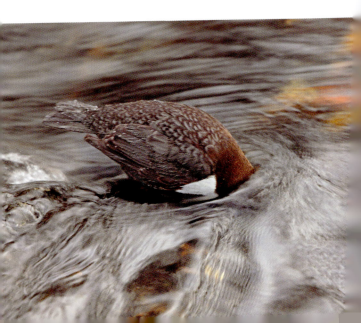

16 Wednesday

17 Thursday
St Patrick's Day, Holiday (Rep. Ireland, N. Ireland)

18 Friday

19 Saturday     20 Sunday
Palm Sunday (Christian)
Spring Equinox

**Dipper dipping**
*by Malte Parmo*
Each winter near Malte's home, close to Copenhagen, dippers fish for insect larvae, grasping the slippery rocks and pebbles with their strong legs and sharp claws. Malte chose a slow shutter speed to show the water flowing around them, but it only worked if the bird kept still. 'Most of the pictures were blurry,' he said. 'With this one, I think I managed to get the feeling of running water and an almost vibrating active dipper.'

# March

WEEK 13

### 21 Monday

### 22 Tuesday

### 23 Wednesday
Full moon ○

### 24 Thursday
Maundy Thursday (Christian)

**Pasque perfection**
*by Daniel Eggert*
Since he had first fallen in love with pasque flowers Daniel had wanted to photograph them covered in hoar frost, so one frosty, sunny dawn, he headed to where they grew. 'I found the ideal flowers to photograph, but I didn't have much time,' he says. 'I knew that as soon as the sun rose, the frost would melt.' On chalky grasslands across Europe, the pasque flower is one of the heralds of spring, flowering around Easter, for which it gets its name.

25 Friday

Good Friday (Christian)
Holiday (UK, Rep. Ireland, Canada, Australia, New Zealand)

26 Saturday

27 Sunday

Easter Sunday (Christian)
British Summertime begins (BST)

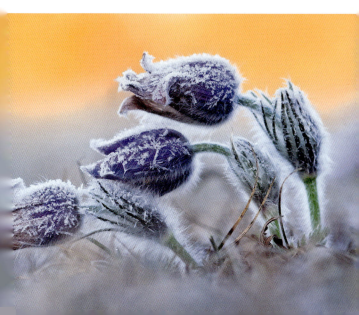

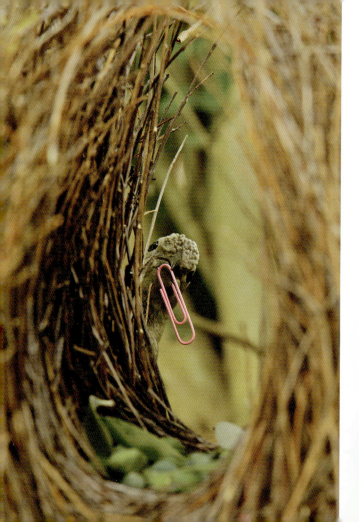

March – April                                                                                                    WEEK 14

**28 Monday**
Easter Monday (Christian)
Holiday (UK excl. Scotland, Rep. Ireland, Canada, Australia, New Zealand)

**29 Tuesday**

**30 Wednesday**

**31 Thursday**

**Friday**
April Fool's Day

**Saturday**

**Sunday**

---

### The paper-clip suitor
*by Tim Laman*

Male bowerbirds are famous for collecting various random items, in this instance a pretty pink paper clip, to tempt prospective mates. After enticing a female to enter his bower – a 'bivouac' of twigs – a male will choose one of his prized decorations and strut back and forth in front of the entrance, showing off to her. Tim photographed this bower in Queensland, Australia. 'This,' he says, 'is the female's view from inside the bower, with the eager male, mid-strut, peering back at her.'

# April

WEEK 15

### 4 Monday

### 5 Tuesday

### 6 Wednesday

### 7 Thursday

New moon ●

**A movement of trees**
*by Cezariusz Andrejczuk*
Cezariusz is fascinated by creating what he calls 'movances' – images of stationary subjects made by moving the camera in various ways, a style derived from his work as a film cameraman. Working from a train, he used a long exposure to achieve a series of images of these silver birches, moving the camera in the direction of travel. For Cezariusz, such pictures 'reveal the underlying and mysterious vibrations of nature.'

8 Friday

9 Saturday

10 Sunday

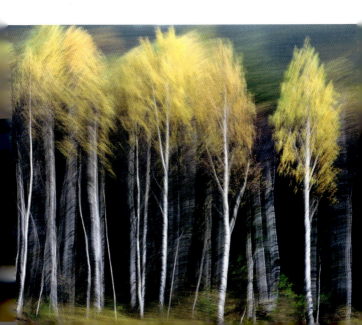

April                                                      WEEK 16

11 Monday

12 Tuesday

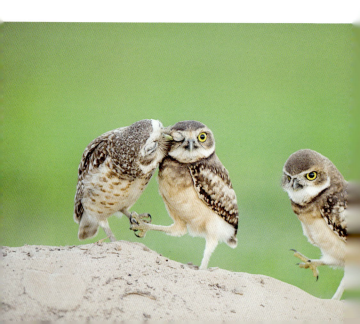

13 Wednesday

14 Thursday

15 Friday

16 Saturday

17 Sunday

**Attention time**
*by Bence Máté*
These newly fledged burrowing owl chicks were impossible to photograph for much of the day. 'In the sweltering heat, they would tuck themselves into the shade of my hide,' says Bence. But as soon as the temperature cooled, they would flutter up to the top of the spoil-heap created when their parents had first excavated the nest hole. For a week, Bence crawled into his hide at about 6pm to photograph them in the short window of opportunity before the sun set over the Pantanal, Brazil.

April                                                                      WEEK 17

18 Monday

19 Tuesday

20 Wednesday

21 Thursday
                                              Queen Elizabeth II's Birthday

**Homage to stilts**
*by Yossi Eshbol*
Yossi has been photographing black-winged stilts for more than 20 years. To him, they epitomize elegance. This picture is his all-time favourite, aesthetically but also because of the tender moment it shows – a mother and her newly hatched chicks, alongside the egg she is still incubating. It was taken close to Yossi's home at salt ponds in Atlit, Israel. The stilts nest offshore, away from predators, building their nests out of salt crystals, which they scoop up from the bottom of the ponds.

22 Friday

First day of Passover (Jewish)
Full moon ○

23 Saturday

St George's Day (England)

24 Sunday

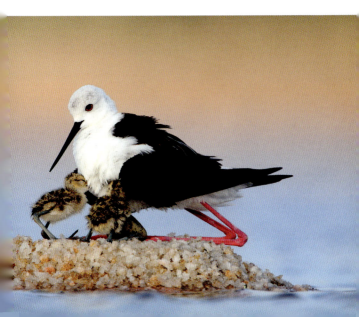

April – May

WEEK 18

25 Monday

Anzac Day, Holiday
(Australia, New Zealand)

26 Tuesday

27 Wednesday

28 Thursday

**In the light of dawn**
*by Frits Hoogendijk*
A blanket of fog lay thickly over the Okavango Delta's Duba Plains, Botswana and the dawn light was very low. The pride had not eaten for several days, and a hunt was likely. 'I wanted to photograph one of the lions out in the open, in the misty weather. So we positioned the vehicle where they might walk towards us. When this lioness stopped and peered into the distance, it was perfect. Its focused gaze captures the energy and intensity of a hunt that hasn't yet happened,' says Frits.

29 Friday

30 Saturday

1 Sunday

Last day of Passover (Jewish)

# May

WEEK 19

2 Monday
Early May Holiday (UK, Rep. Ireland)

3 Tuesday

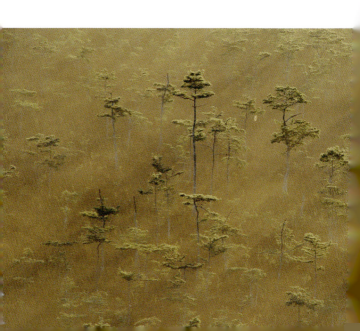

4 Wednesday

5 Thursday

Cinco de Mayo (USA)
Ascension Day (Christian)

6 Friday

New moon ●

7 Saturday

8 Sunday

Mother's Day
(USA, Canada, Australia, New Zealand)

### Cypress swamp in golden dawn
*by Ralph Arwood*
Twice a year, Ralph, a volunteer photographer at the Big Cypress National Preserve, joins biologists as they fly out to monitor white-tailed deer. 'The ground fog rising from the water crystallized the light,' he says. 'A huge, glistening spider's web hanging from one of the bald-cypress trees added the perfect accent to a mystical view of the swamp.' The preserve covers 729,000 acres of wetland in Florida's Everglades, home to mangroves, alligators and panthers; the bald cypress is one of its most common trees.

## May

WEEK 20

9 Monday

10 Tuesday

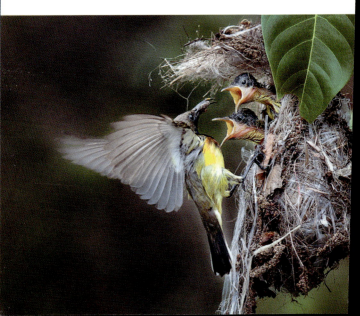

11 Wednesday

12 Thursday

13 Friday

14 Saturday

15 Sunday
Pentecost/Whitsun
(Christian)

**The sunbird brood**
*by Hui Yu Kim*
The olive-backed sunbirds had their work cut out feeding their growing clutch of babies. Hui Yu counted them coming to the nest five times in ten minutes. The mother had built the nest in Hui Yu's back garden in Sungai Petani, Malaysia. She had threaded spiderwebs among the other materials, including bits of string, so the nest could stretch as the babies grew. 'After a week,' says Hui Yu, 'the babies' heads poked out of the nest, and we could watch them being fed.'

May

WEEK 21

16 Monday

17 Tuesday

18 Wednesday

19 Thursday

**Fairy Lake fir**
*by Adam Gibbs*
Much of the area around Port Renfrew, on the west coast of Canada's Vancouver Island, has been heavily logged. So for Adam, this miniature Douglas fir growing out of a Douglas fir stump in the middle of Fairy Lake was symbolic. 'It always amazes me how resilient nature is and what a tenacious existence some plants live.' Adam focused in on it to exclude the vegetation around the lake and, waiting for a mirror-still moment, used the reflection of its surroundings as the backdrop.

20 Friday

21 Saturday
Full moon ○

22 Sunday
Trinity Sunday (Christian)

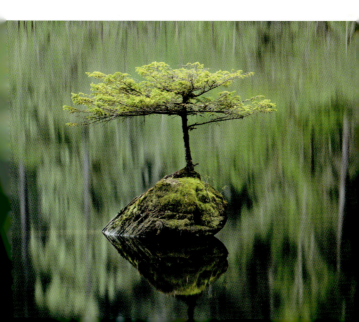

May

WEEK 22

23 Monday
Victoria Day, Holiday (Canada)

24 Tuesday

25 Wednesday

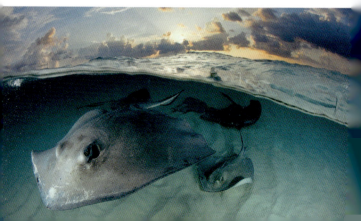

26 Thursday

Corpus Christi (Christian)

27 Friday

28 Saturday

29 Sunday

**Evening rays**
*by Claudio Gazzaroli*
North Sound, off the island of Grand Cayman, is a hotspot for 'friendly' southern stingrays. Inspired by David Doubilet's original split-level portrait of a Cayman stingray, Claudio set out to photograph the stingrays with a different perspective. 'There were about 75 of them undulating through the shallows,' he says. Balancing the light was a problem 'because of the extremes in contrast between the dramatic evening sky and sandy sea bottom', but keeping snorkellers who gather to meet these charismatic fish out of the picture proved to be more of a challenge.

May – June                                                                                           WEEK 23

30  Monday
                                                                                      Spring Holiday (UK)
                                                                                 Memorial Day, Holiday (USA)

31  Tuesday

1  Wednesday

2  Thursday

**Treading water**
*by Charlie Hamilton James*
While making a film about giant otters in Cocha Salvador, Manu National Park, Peru, Charlie got to know this youngster well. 'He was full of personality,' says Charlie. 'These animals have a lot of attitude.' They are very social and live in extended family groups, with up to eight or so members. The portrait of the four-month-old cub was taken while Charlie was lying down in his boat. The cub was as curious about Charlie as Charlie was about the cub, craning its neck while treading water.

3 Friday

4 Saturday

5 Sunday

New moon ●

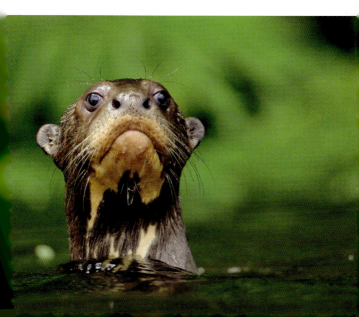

June WEEK 24

6 Monday

Holiday (Rep. Ireland)
Queen Elizabeth II's Birthday, Holiday (New Zealand)
Ramadan begins (Islamic)

7 Tuesday

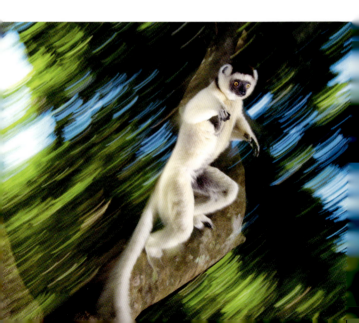

8 Wednesday

9 Thursday

10 Friday

11 Saturday     12 Sunday

**Leaping lemur**
*by Heinrich van den Berg*
Verreaux's sifakas are often photographed crossing open ground, jumping upright, as if on springs. But what impressed Heinrich was the way they moved between trees. 'They spring off their back legs, then twist in the air to land perfectly on the next trunk,' he says. These tree-dwelling lemurs are found only in Madagascar. Although not the most endangered of the island's lemurs, their numbers are dwindling, as more and more of the forest and lowland habitat on which they depend is destroyed.

June  WEEK 25

13 Monday

14 Tuesday

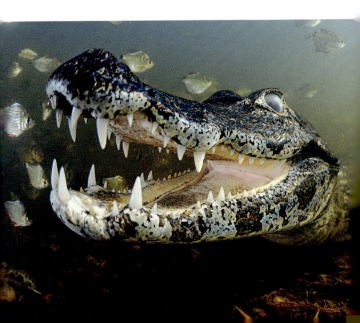

15 Wednesday

16 Thursday

17 Friday

18 Saturday

19 Sunday

Father's Day
(UK, Rep. Ireland, USA, Canada)

**The piranha-eater**
*by Marcelo Krause*
Most rivers in Brazil's Pantanal have zero visibility, so photographing yacare caiman under water is not easy. When Marcelo entered the Vazante do Castelo river, his intention was to photograph piranhas, but when he put out bait to attract them, several large yacare arrived, probably attracted by all the movement and finding plenty of piranhas to eat. 'This huge one warned me off by opening its mouth,' says Marcelo. 'Then some of them started to bite my camera housing – time to get back in the boat.'

June

WEEK 26

20 Monday

Summer Solstice
Full moon ○

21 Tuesday

22 Wednesday

23 Thursday

24 Friday

25 Saturday

26 Sunday

**Turtle gem**
*by Jordi Chias*
Armeñime, a small cove off the coast of Tenerife, is a hotspot for green sea turtles, which come to forage on the plentiful seagrass. Jordi cruised with this one in the shallow, gin-clear water. 'The dazzling colours and textured patterns were mesmerising,' says Jordi, 'and I was able to compose a picture showing just how beautiful this marine treasure is.' Like the other seven species of sea turtle, the green sea turtle is still hunted for its beautiful shells, so is sadly endangered.

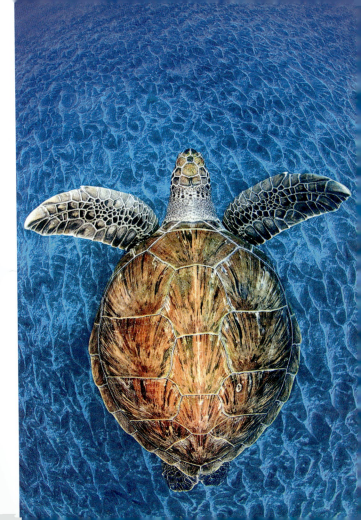

June – July

WEEK 27

27 Monday

28 Tuesday

29 Wednesday

30 Thursday

**Love under the lens**
*by András Mészáros*
The macro lens has opened up a new world for András. 'I take every opportunity to catch a glimpse of the lives of tiny insects,' he says. When he found these snail-killing flies mating on a grass stem, what struck him was not only their beautiful markings, but also 'the female's seeming surprise to find another insect on her back.' Little is known about this particular Central European species, but it probably lays its eggs on leaves in the vicinity of snails or directly onto snail shells.

3 Friday
Canada Day, Holiday (Canada)

4 Saturday     5 Sunday

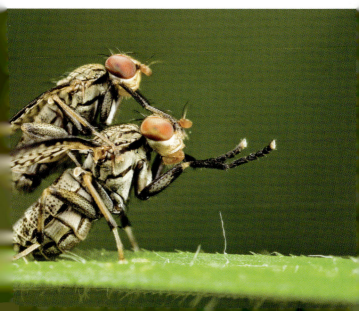

July

WEEK 28

### 4 Monday

Independence Day, Holiday (USA)
New moon ●

### 5 Tuesday

Ramadan ends (Islamic)

### 6 Wednesday

### 7 Thursday

**Pester power**
*by Mateusz Piesiak*
Mateusz wrapped his camera in a waterproof sack, dropped onto his belly and began to crawl along the wet sand. His aim was to get close to a small group of American oystercatchers foraging for shellfish on a beach on Long Island, New York. One young oystercatcher kept trying to find its own food. 'As soon as it saw an adult with a morsel,' says Mateusz, 'it would run over with loud, begging queep queep cries and try to snatch it from them.'

8 Friday

9 Saturday

10 Sunday

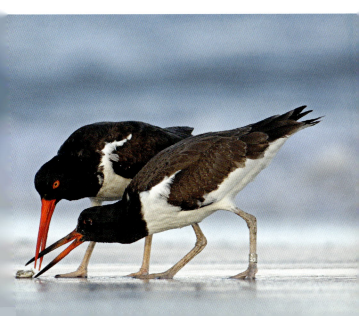

July

WEEK 29

11 Monday

12 Tuesday

Battle of the Boyne, Holiday (N. Ireland)

13 Wednesday

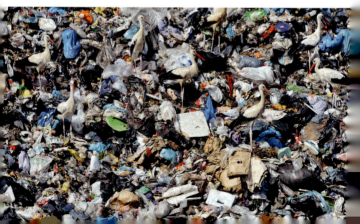

## 14 Thursday

St Swithin's Day (Christian)

## 15 Friday

## 16 Saturday

## 17 Sunday

### Garbage picking
*by Jasper Doest*

'This was the filthiest shoot I have ever done,' says Jasper. 'Clambering about this ghastly landfill site made me aware of just how much trash we generate on a daily basis.' For these white storks, rubbish dumps have become increasingly important, providing a constant food source during both the breeding season and winter. While these sites may provide the elegant storks with a bountiful supply of food, studies of gull chicks raised on landfill have revealed slower growth rates and shorter life expectancies.

July
WEEK 30

18 Monday

19 Tuesday
Full moon ○

20 Wednesday

21 Thursday

**The eye of the baitball**
*by Cristobal Serrano*
Cristobal watched the great circling shoal of grunt fish for two days. 'With the sky behind the fish ball,' he says, 'it looked like a shimmering body of energy. I just needed a focal point to get the picture I was after.' Now and then a cormorant would shoot through the ball, using its huge webbed feet for propulsion, and pick off fish. Using a fisheye lens and strobes, Cristobal captured the shot.

22 Friday

23 Saturday  24 Sunday

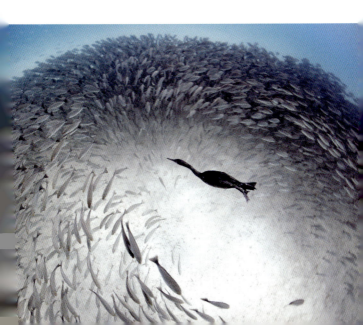

July

25 Monday

26 Tuesday

WEEK 31

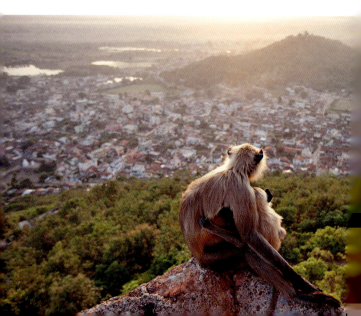

27 Wednesday

28 Thursday

29 Friday

30 Saturday

31 Sunday

**Sunset moment**
*by Olivier Puccia*
Squeezed out of their forest homes by deforestation and the spread of human habitation, Hanuman langurs have become part of urban life in many parts of India. Olivier visited a hilltop temple overlooking Ramtek in Maharashtra, western India. As the sun began to set, he tried to find the highest point from which to admire the glorious scene. Just below, this mother and baby were wrapped in each other's arms, staring across the valley. 'It was a touching moment,' says Olivier, 'as though they were appreciating the sunset together.'

# August

WEEK 32

1 Monday

Summer Holiday (Scotland, Rep. Ireland)

2 Tuesday

New moon ●

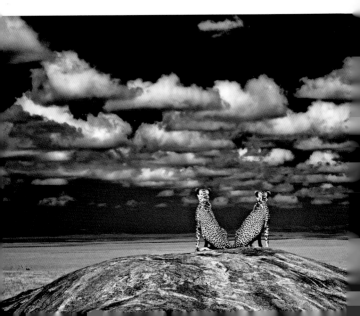

3 Wednesday

4 Thursday

5 Friday

6 Saturday

7 Sunday

**Lookout for lions**
*by Charlie Hamilton James*
Charlie was filming lions around the Gol Kopjes area of the Serengeti National Park in Tanzania when he came across these cheetahs. They, too, were watching lions. 'Once the danger had gone,' Charlie says, 'they relaxed into a gloriously symmetrical pose, in the middle of a curved rock, under a symmetry of clouds, crowned by a perfectly positioned small cloud at the top ... Normally when taking wildlife pictures, everything conspires against the photographer, but with this picture it was the reverse. Everything worked in harmony.'

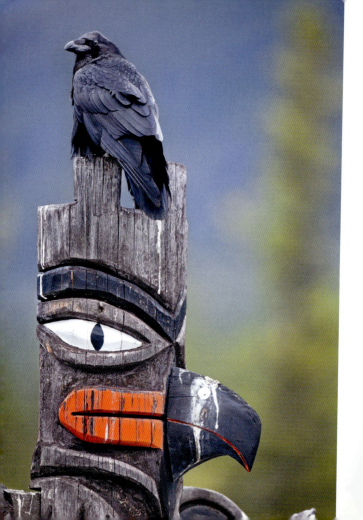

## August

WEEK 33

8 Monday

9 Tuesday

10 Wednesday

11 Thursday

12 Friday

13 Saturday

14 Sunday

**Raven icon**
*by Vladimir Medvedev*
Vladimir was preoccupied with a task when the raven landed on the totem pole in Canada's Jasper National Park. He knew that the raven had great cultural significance. 'According to the myths of the indigenous North Americans, the raven is the god that founded the world,' he says. There was evidence that the totem was regularly used as a perch, and Vladimir assumed that it was one of the raven's favourite spots. He took one shot before the raven flew away.

August                                                                 WEEK 34

15 Monday

16 Tuesday

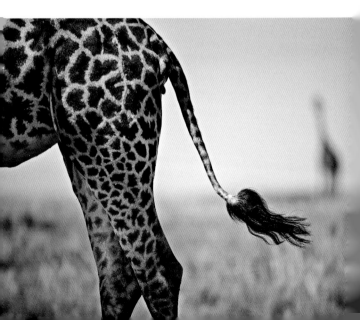

17 Wednesday

18 Thursday

Full moon ○

19 Friday

20 Saturday        21 Sunday

**In the flick of a tail**
*by David Lloyd*
Photographers generally agree that giraffes, though easy enough to find, are tricky to photograph. 'They're so big that you either have to be far back ... or you have to close in on detail,' says David. He saw the potential of the latter option when, in Kenya's Masai Mara, he encountered a giraffe at close quarters, and saw a second one on the horizon. He got himself into position and waited for something that would inject life into the scene – a tail flick.

August

WEEK 35

22 Monday

23 Tuesday

24 Wednesday

25 Thursday

**City gull**
*by Eve Tucker*
As Eve walked through the financial district of Canary Wharf, London a bird caught her eye. It was a black-headed gull, resting on the reflection of a nearby office block, its straight lines distorted into moving swirls. 'The effect was so unusual – it gave a beautiful setting for an urban wildlife image,' she says. These seabirds take their name from their summer plumage – when their heads turn a deep chocolate brown colour. The rest of the year this hood recedes to a dark spot behind the eye.

26 Friday

27 Saturday                    28 Sunday

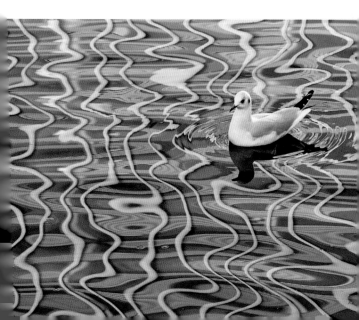

August – September                                         WEEK 36

29 Monday
                                                   Summer Holiday (UK excl. Scotland)

30 Tuesday

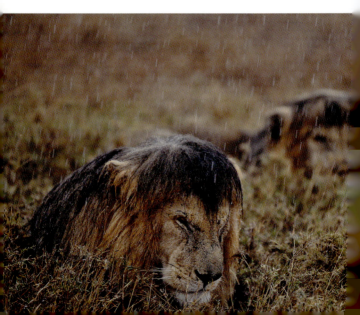

31 Wednesday

1 Thursday

New moon ●

2 Friday

3 Saturday

4 Sunday
Father's Day (Australia, New Zealand)

**Sharing a shower**
*by Michael 'Nick' Nichols*
This was the first time Nick had come across these two adult males in Tanzania's Serengeti National Park. 'I later learnt the two lions had been pushed out of their group by a coalition of four other males,' says Nick. Pairs of male lions are common. They form coalitions for protection and to make hunting more efficient. The downpour is not as unwelcome as their expressions suggest. Water is scarce and closely bonded lions often lick water from each other's fur for a quick drink.

## September

WEEK 37

**5 Monday**

Labor Day, Holiday (USA, Canada)

**6 Tuesday**

**7 Wednesday**

**8 Thursday**

**Tern style**
*by Ilkka Räsänen*
In the summer holidays, Ilkka goes fishing on the shores of Lake Saimaa, Finland and has been photographing common terns there since he was seven years old. What fascinates him most is the way they fly. 'They have long wings, which make it look as though their body springs up when their wings go down. They dive at high speed, sometimes so deep that they go right under the surface. I love photographing the action and the way the light sparkles through the water drops.'

9 Friday

10 Saturday

11 Sunday

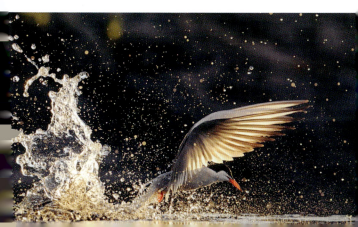

## September

WEEK 38

12 Monday

13 Tuesday

14 Wednesday

15 Thursday

**The warning**
*by Gaurav Ramnarayanan*
An Indian jackal slunk out of the bushes, glancing nervously behind it. Clearly something was going on. Gaurav, on safari in Keoladeo Ghana National Park, leapt out of his rickshaw to set up his tripod. Seconds later, a pair of jackals emerged, snarling. The first 'crouched submissively as the pair emphasized their warning, and then they parted without a fight,' says Gaurav. For the pair facing the photographer, it is all about a show of dominance but jackals do not generally fight unless they have to.

16 Friday

Full moon ○

17 Saturday

18 Sunday

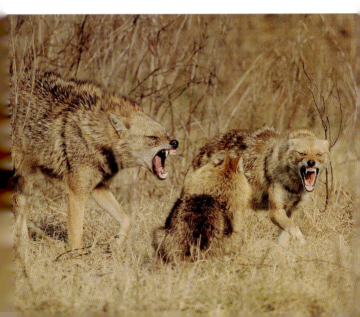

September

WEEK 39

19 Monday

20 Tuesday

21 Wednesday

22 Thursday

Autumn Equinox

**Last look**
*by Steve Winter*
This is a very special tiger. He is one of fewer than 400–500 wild, critically endangered Sumatran tigers. Those that have escaped poaching and forest clearance for oil-palm plantations are extremely shy. A former tiger hunter, now employed as a park ranger, advised Steve where to set up his camera trap. But the challenge remained to position the remote-control camera and the lights in exactly the right position so the tiger would be lit centre-stage in front of a backdrop of forest habitat.

23 Friday

24 Saturday            25 Sunday

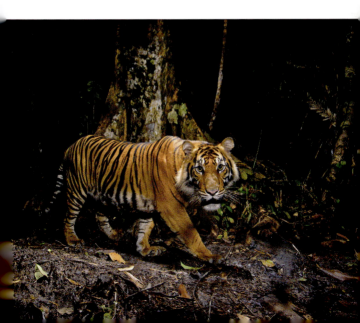

September – October

WEEK 40

26 Monday

27 Tuesday

28 Wednesday

29 Thursday

**Fire on the Pantanal**
*by Bence Máté*
Bence first smelt the fire before seeing 'the awe-inspiring sight' stretching across the Pantanal, Brazil. It may have been started naturally or by cattle farmers clearing the land to stimulate grass growth. 'With such intense firelight, it was a challenge to work out how to photograph the scene. I used a long-exposure and stretched out my arm to cover the flames with my hands to expose the stars. Then, for the last second or so, I took away my hands to expose the flames.'

30 Friday

1 Saturday
New moon ●

2 Sunday
Rosh Hashanah (Jewish New Year)

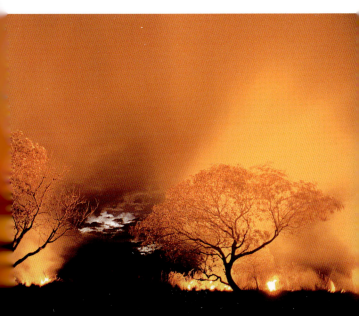

# October

WEEK 41

### 3 Monday
Al-Hijira/Islamic New Year (Islamic)

### 4 Tuesday

### 5 Wednesday

### 6 Thursday

**Night eyes**
*by Tim Laman*
Not once in 20 years of searching on the island of Borneo had Tim ever seen a Horsfield's (or western) tarsier – a small, rare and secretive primate. Then, on a nocturnal sortie, he finally found one. 'Tarsiers are totally nocturnal, so my goal was to capture the feel of night,' says Tim. 'I kept my flash toned down and at an angle to illuminate the tarsier's special features: its toe pads for clinging to small trees, the sensitive, directional ears and those huge eyes for night vision.'

7 Friday

8 Saturday

9 Sunday

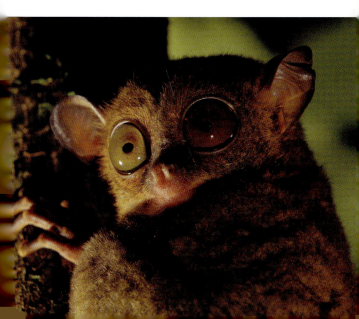

October   WEEK 42

### 10 Monday
Columbus Day, Holiday (USA)
Thanksgiving Day, Holiday (Canada)

### 11 Tuesday

### 12 Wednesday
Yom Kippur (Jewish)

### 13 Thursday

---

**Rock art**
*by Verena Popp-Hackner*
For more than a month, Verena photographed the ridges of sandstone on Norway's Varanger Peninsula. 'Every time I went, a new combination of light, tide and weather made the seaweed-covered rocks look different,' she says. 'Some colours were stronger when the rock was wet. Others reflected indirect sunlight well. Others were better in shade.' Eventually, on a stormy day at high tide, balanced on a slippery ridge, Verena used a long exposure to soften the water as a contrast to the rocks '...the colour combination was pure magic.'

14 Friday

15 Saturday                          16 Sunday
                                              Full moon ○

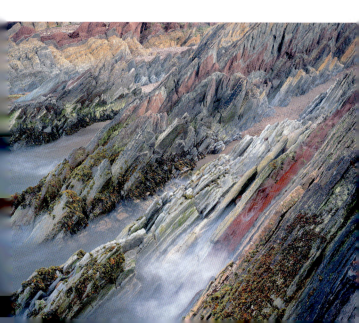

## October

WEEK 43

17 Monday

18 Tuesday

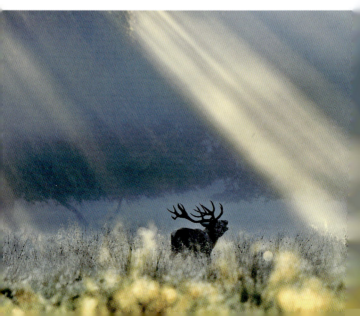

19 Wednesday

20 Thursday

21 Friday

22 Saturday

23 Sunday

**Dawn call**
*by Pierre Vernay*
The roar of a red deer stag carries an unmistakable message – the more powerful the roar, the stronger the stag. To catch the action of the rut, Pierre stationed himself in Dyrehaven forest, an ancient deer park north of Copenhagen in Denmark. Going out at dawn, he planned to photograph the deer backlit against the rising sun. Just as the very first beams of sunshine lit up the grass, a stag emerged from below a huge oak tree to challenge a rival that had strayed too close.

October                                                              WEEK 44

24 Monday
                                                      Labour Day, Holiday (New Zealand)

25 Tuesday

26 Wednesday

27 Thursday

**Warning night light**
*by Larry Lynch*
One evening, while walking along the riverbed of the Myakka River State Park in Sarasota, Florida, Larry came across a group of alligators. This big alligator had been gorging on fish, 'it wasn't going anywhere in a hurry,' says Larry, 'so I set my tripod and camera up about seven metres in front of him and focused on his eyes.' Just after sunset, Larry set his flash on the lowest setting to give just a tiny bit of light, enough to catch the eyeshine in the alligator's eyes.

28 Friday

29 Saturday

30 Sunday

British Summertime ends (BST)
Diwali (Hindu, Sikh)
New moon ●

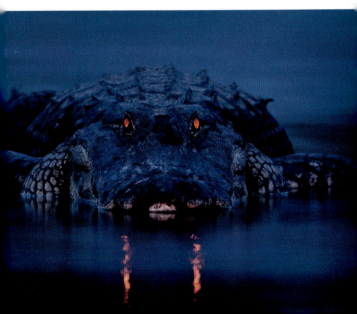

# October – November

WEEK 45

### 31 Monday

Halloween
Holiday (Rep. Ireland)

### 1 Tuesday

All Saints' Day (Christian)

### 2 Wednesday

### 3 Thursday

**The cove by moonlight**
*by Miquel Angel Artús Illana*
Shallow, sheltered and warm, this corner of the Sa Banyera de Ses Dones cove at Tossa de Mar, northeast Spain, is more bath than bay, shielded by the rocks from the wind. For nearly a year Miquel tried to create his ideal image, using just the light of the moon, without night divers and fishermen visible and without light pollution from the nearby promenade casting strong shadows. Finally, one night offered the perfect combination of a full moon, cloud and strong winds.

4 Friday ——————————————————————————————

5 Saturday ——————————————————— 6 Sunday ——————————————————
            Guy Fawkes Night (UK)

# November

WEEK 46

### 7 Monday

### 8 Tuesday

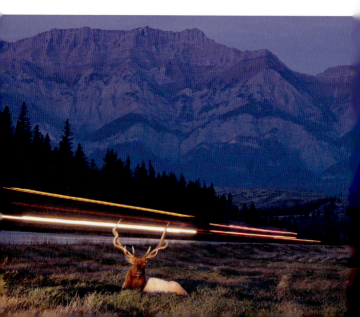

9 Wednesday

10 Thursday

11 Friday
Armistice Day
Veterans Day, Holiday (USA)

12 Saturday

13 Sunday
Remembrance Sunday

### Life in the border zone
*by Vladimir Medvedev*
The stillness of the red deer stag in the twilight made it almost invisible to motorists speeding down the highway through Jasper National Park, Canada. But its silhouette caught Vladimir's eye. By the time he had pulled over, this image was already in his mind. 'I wanted to show how the natural world often exists so close to us, yet is so often unseen,' he says. Vladimir positioned his tripod and set the shutter speed low, so that headlights would leave the longest light trail possible.

November

WEEK 47

14 Monday

Full moon ○

15 Tuesday

16 Wednesday

17 Thursday

18 Friday

19 Saturday

20 Sunday

**Swoop of the sea scavenger**
*by Roy Mangersnes*
Roy set out to shoot an image that conveyed the sheer size and power of the white-tailed eagle, which are among the world's largest birds of prey with a wingspan of around 2.2 metres (7 feet). He shot from a boat in a fjord using fish bait. 'I chose a long lens even though the eagle would be very close,' says Roy. The challenge was to hold the heavy 500mm lens steady on a rocking boat and to follow the swooping bird with a tight frame.

November                                              WEEK 48

21 Monday

22 Tuesday

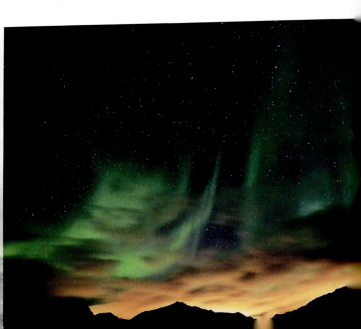

23 Wednesday

24 Thursday

Thanksgiving, Holiday (USA)

25 Friday

26 Saturday

27 Sunday

**Celestial cathedral**
*by Kent Miklenda*
The aurora borealis – here taking place in the night sky over the Lofoten Islands, northern Norway – 'was a sublime experience,' says Kent, who was in awe when observing the cosmic display. 'Standing under the brilliant roof of stars and shimmering curtains of light was evocative of being in a kind of celestial cathedral.' The natural physics behind the phenomenon is also impressive, involving atomic collisions of the solar winds and the Earth's magnetic field lines creating ionizing gases that flux and glow in the atmosphere.

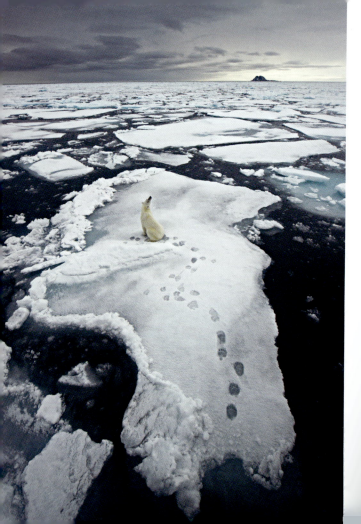

November – December                                          WEEK 49

28 Monday

29 Tuesday
                                                              New moon ●

30 Wednesday
                                          St Andrew's Day, Holiday (Scotland)

1 Thursday

2 Friday

3 Saturday

4 Sunday

**Living on thin ice**
*by Ole Jørgen Liodden*
Ole had photographed polar bears more than a hundred times around the islands of Svalbard, northern Norway, but on this particular summer evening, everything came together to sum up the bear and its ice environment. 'The landscape, the shape of the ice floe, the shape of the bear and the footprints were just perfect,' says Ole. Drifting ice is normal for midsummer in the region. But, says Ole, two weeks later, all the ice around Svalbard had melted, much earlier than in previous years.

December

WEEK 50

5 Monday

6 Tuesday

7 Wednesday

8 Thursday

**March of the coots**
*by Andrew George*
Winter 2010 in Eindhoven, The Netherlands was one of the coldest in years. Large congregations of coots are a common sight there during winter. At the ice-covered lake, coots were polishing off scraps of bread people had thrown them. As soon all the food was gone, the birds headed back towards the only remaining hole in the ice. 'It reminded me of a scene from March of the Penguins,' Andrew says, 'even though I was in my local park, in the city.'

9 Friday

10 Saturday — 11 Sunday

December

WEEK 51

**12 Monday**

Milad un Nabi, Birthday of the Prophet Muhammad (Islamic)

**13 Tuesday**

**14 Wednesday**

Full moon ○

**15 Thursday**

**Snow pounce**
*by Richard Peters*
Richard sat in his car in Yellowstone National Park, in Wyoming, USA and watched the fox hunting, just enjoying the performance. The fox was listening for rodents under the snow then leaping high to pounce down on the unsuspecting prey. It was too far away to photograph, so when it disappeared and suddenly reappeared, on a snow bank level with the car window, Richard 'barely had time to lift the camera before it leapt into the air almost clean out of my field of view.'

16 Friday

17 Saturday

18 Sunday

## December

WEEK 52

**19** Monday

**20** Tuesday

**21** Wednesday

Winter Solstice

**22** Thursday

---

**Frozen in flight**
*by Jamie Unwin*
It was Christmas morning when Jamie set up the shoot in his back garden. 'I wanted a bird in flight, centred with the sun top left,' he says. He placed grain on the snow in a precise spot and waited. 'This great tit landed on target and then lifted off in a flurry of snow.' On take-off, the twisting wingtips pull the bird through the air like propellers. This was the only picture Jamie took – the result is one spectacular action shot.

23 Friday

24 Saturday
Christmas Eve (Christian)
Chanukkah, Festival of Lights begins (Jewish)

25 Sunday
Christmas Day (Christian)

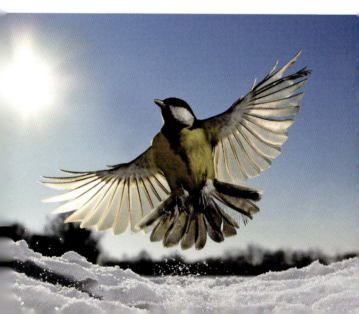

## December

WEEK 53

### 26 Monday

Boxing Day, Holiday (UK, Rep. Ireland, Canada, Australia, New Zealand)
Christmas Day, Substitute Holiday (Christian) (USA)

### 27 Tuesday

Christmas Day, Substitute Holiday (Christian)
(UK, Rep. Ireland, Canada, Australia, New Zealand)

### 28 Wednesday

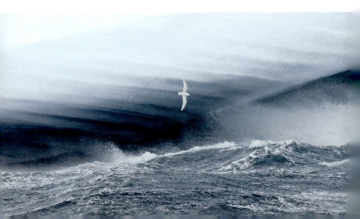

29 Thursday

New moon ●

30 Friday

31 Saturday

New Year's Eve
Hogmanay (Scotland)

1 Sunday

New Year's Day
Holiday (UK, Rep. Ireland, USA, Canada, Australia, New Zealand)
Chanukkah, Festival of Lights ends (Jewish)

**Where petrels dare**
*by Mark Tatchell*
It was blowing a good Southern Ocean gale that December day as Mark's ship headed south from South Georgia. Huge tabular icebergs, drifting north from the Weddell Sea, gave an extra edge to the windswept journey. Daring snow petrels swooped between them. Mark wanted to capture a shot that would 'combine the beauty of the ice, the power of the boiling sea and the elegance of the birds in flight.' The moment came when a single bird swept close to the wave-cut base of an enormous berg.

# Index of photographers

**Week 15**
A movement of trees
**Cezariusz Andrejczuk**
Poland
ksian@pro.onet.pl
www.cezariusz.com
Canon EOS 5D Mark II + EF 85mm f1.8 lens; 0.25 sec at f9.5; ISO 200.

**Week 45**
The cove by moonlight
**Miquel Angel Artús Illana**
Spain
www.artus.es
Nikon D7000 + Sigma 10-20mm f3.5 lens at 10mm; 300.8 sec at f11; ISO 100; Giotto tripod.

**Week 19**
Cypress swamp in golden dawn
**Ralph Arwood**
USA
photo@ralpharwood.com
www.ralpharwood.com
Nikon D3 + 80-400mm lens at 400mm; 1/2000 sec at f8 (-1 e/v); ISO 1600.

**Week 11**
Light show
**Sandra Bartocha**
Germany
info@bartocha-photography.com
www.bartocha-photography.com
Agent: www.naturepl.com
Sony NEX-5 + Nikon 50mm f1.4 lens; 1/640 sec at f1.4; ISO 200; Lensbaby Tilt Transformer.

**Week 5**
Mist rising at sunset
**Sander Broström**
Sweden
info@sanderbrostrom.com
www.sanderbrostrom.com
Canon EOS 7D + 70-200mm f2.8 lens; 1/1600 sec at f8; ISO 400.

**Week 7**
Aurora over ice
**Thilo Bubek**
Germany
thilo@bubek.com
www.bubek-fotodesign.com
Nikon D3 + 14-24mm f2.8 lens at 17mm; 3 sec at f2.8; ISO 1600; Berlebach UNI 15 tripod + FLM 58 ball head; Nikon Capture NX2, stitched with PTGui Pro 8.

**Cover & week 26**
Turtle gem
**Jordi Chias**
Spain
jordi@uwaterphoto.com
www.uwaterphoto.com
Canon EOS 7D + Tokina 10-17mm lens at 10mm; 1/80 sec at f11; ISO 160; custom-made housing; two Inon flashes.

**Week 1**
Relaxation
**Jasper Doest**
The Netherlands
info@jasperdoest.com
www.jasperdoest.com
Nikon D3 + 105mm f2.8 lens; 1/200 sec at f16; ISO 200.

**Week 29**
Garbage picking
**Jasper Doest**
Nikon D3 + 70-200mm f2.8 lens; 1/1000 sec at f11; ISO 400.

**Week 13**
Pasque perfection
**Daniel Eggert**
Germany
eggert.daniel@arcor.de
www.natur-motive.de
Canon EOS 350D + Sigma 105mm lens; 1/125 sec at f5; ISO 200; beanbag.

**Week 17**
Homage to stilts
**Yossi Eshbol**
Israel
eshbol@bezeqint.net
Agent: www.flpa-images.co.uk
Nikon D300 + 600mm f4 lens; 1/800 sec at f6.3 (-1.7 e/v); ISO 200; tripod; hide.

**Week 2**
Celebration of a grey day
**Fortunato Gatto**
Italy
fortunato.gatto@gmail.com
www.fortunatophotography.com
Canon EOS 5D Mark II + Zeiss Distagon T* 21mm f2.8 lens; 121 sec at f16; ISO 50; Giotto tripod + remote; Lee Neutral Density 0.6 hard & soft filters + neutral density 0.9 filter.

**Week 22**
Evening rays
**Claudio Gazzaroli**
Switzerland
info@gazzaroli.ch
www.claudiogazzaroli.com
Canon EOS 5D Mark II + 15mm lens; 1/160 sec at f16; ISO 200; Nexus housing; two Subtronic Mega Color strobes.

**Week 50**
March of the coots
**Andrew George**
The Netherlands
a.george@chello.nl
www.agfoto.nl
Agent: www.natureinstock.com
Nikon D700 + 70-200mm f2.8 lens; 1/60 sec at f8; ISO 800.

**Week 21**
Fairy Lake fir
**Adam Gibbs**
Canada/UK
adam@adamgibbs.com
www.adamgibbs.com
Canon EOS 5D Mark II + 100-400mm f4.5-5.6mm lens at 350mm; 20 sec at f22; ISO 50.

**Week 3**
Snowed in
**Orsolya Haarberg**
Hungary
orsolya.haarberg@freemail.hu
www.haarbergphoto.com
Agents: www.scanpix.no, www.naturepl.com
Nikon D700 + 300mm f2.8 lens; 1/2000 sec at f5.6; ISO 400; Gitzo GT3540LS tripod.

**Week 23**
Treading water
**Charlie Hamilton James**
UK
charlie@halcyon-media.co.uk
www.charliehamiltonjames.com
Canon EOS-1D Mark IV + 800mm lens; 1/1600 sec at f5.6; ISO 1000.

**Week 32**
Lookout for lions
**Charlie Hamilton James**
Canon EOS 5D Mark II infrared converted + 24-105mm lens; 1/250 sec at f10; ISO 100.

**Week 18**
In the light of dawn
**Frits Hoogendijk**
South Africa
frits@tandmuis.co.za
www.natureimages.co.za
Nikon D3S + 200-400mm f4 lens at 200mm; 1/400 sec at f4; ISO 1000.

**Week 20**
The sunbird brood
**Hui Yu Kim**
Malaysia
kim.hui.yu@gmail.com
Nikon D300 + 70-200mm f2.8 lens; 1/1000 sec at f4; ISO 400; cable release; tripod.

**Week 25**
**The piranha-eater**
**Marcelo Krause**
Brazil
marcelo@underwater.com.br
www.marcelokrause.com
Nikon D2x + Tokina AT-X 107 AF 10-17mm f3.5-4.5 lens; 1/250 sec at f5.3; ISO 400; Aquatica D2 housing; Inon Z-240 strobe.

**Week 14**
**The paper-clip suitor**
**Tim Laman**
USA
tim@timlaman.com
www.timlaman.com
Agents: www.natgeocreative.com, www.naturepl.com
Canon EOS-1D + 300mm f2.8 lens + 1.4x extender; 1/45 sec at f8; ISO 640; flash fill.

**Week 41**
**Night eyes**
**Tim Laman**
Canon EOS 5D + 70-200mm f2.8 lens; 1/125 sec at f11; ISO 200; Canon 580EX strobes.

**Week 49**
**Living on thin ice**
**Ole Jørgen Liodden**
Norway
post@naturfokus.no
www.naturfokus.com
Agent: www.naturepl.com
Nikon D3S + 14-24mm f2.8 lens; 1/400 sec at f11; ISO 1000.

**Week 34**
**In the flick of a tail**
**David Lloyd**
New Zealand
david@davidlloyd.net
www.davidlloyd.net
Nikon D700 + 200-400mm lens; 1/3000 sec at f4; ISO 400.

**Week 4**
**Tiptoe lark**
**Henrik Lund**
Finland
henrik.lund@lundfoto.com
www.lundfoto.com
Canon 1D Mark IV + 500mm f4 lens +1.4 x II extender; 1/800 sec at f6.3; ISO 800.

**Week 44**
**Warning night light**
**Larry Lynch**
USA
lynchphotos@aol.com
www.lynchphotos.com
Nikon D2X + 80-400mm f4.5-5.6 lens; 3 sec at f8; ISO 200; SB-800 flash; Gitzo 3125 tripod; Manfrotto 468RC2 Ball Head.

**Week 47**
**Swoop of the sea scavenger**
**Roy Mangersnes**
Norway
roy@wildphoto.no
www.roymangersnes.com
Agent: www.naturepl.com
Nikon D3s+ 500mm f4 lens; 1/3200 sec at f8; ISO 500.

**Week 16**
**Attention time**
**Bence Máté**
Hungary
bence@matebence.hu
www.matebence.hu
Nikon D700 + 300mm f2.8 lens; 1/320 sec at f2.8; ISO 1600; Gitzo tripod; hide.

**Week 40**
**Fire on the Pantanal**
**Bence Máté**
Nikon D700 + 20mm f2.8 lens; 20 sec at f2.8; ISO 1000; Gitzo tripod.

**Week 6**
**The snow herd**
**Vladimir Medvedev**
Russia
photo@vladimirmedvedev.com
www.vladimirmedvedev.com
Canon EOS 5D Mark II + 16-35mm f2.8 lens; 1/250 sec at f9; ISO 200.

**Week 33**
**Raven icon**
**Vladimir Medvedev**
Canon EOS 5D Mark II + 500mm f4 lens; 1/250 sec at f4; ISO 200.

**Week 46**
**Life in the border zone**
**Vladimir Medvedev**
Canon EOS 5D Mark II + 70-200mm f4 lens; 1/250 sec at f10; ISO 100.

**Week 27**
**Love under the lens**
**András Mészáros**
Hungary
andras@meszarosandras.com
www.meszarosandras.com
Canon EOS 5D + MP-E 65mm lens + extension tube + mirror lock-up; 1/200 sec at f10; ISO 200; Canon MT24-EX twin flash; Manfrotto 459 ballhead; Gitzo tripod.

**Week 48**
**Celestial cathedral**
**Kent Miklenda**
Australia
xenomundi@bigpond.com
www.kentmiklenda.com
Canon EOS-1Ds Mark III + 16-35mm f2.8 II lens; 38 sec at f2.8; ISO 400; Manfrotto 555B tripod; Yongnuo wireless shutter release.

**Week 36**
**Sharing a shower**
**Michael 'Nick' Nichols**
USA
nickngs@mac.com
http://michaelnicknichols.com
Agent: www.nationalgeographicstock.com
Canon EOS-1D X + 70-200mm f2 lens; 1/350 sec at f10; ISO 400.

**Week 12**
**Dipper dipping**
**Malte Parmo**
Denmark
maltephoto@parmo.org
www.parmo.org
Canon EOS 50D + 70-200mm f4 lens + 1.4x extender; 1/15 sec at f8; ISO 160; Manfrotto tripod.

**Week 9**
**Pelican pack**
**Jari Peltomäki**
Finland
jari@finnature.fi
www.finnature.fi
www.wild-wonders.com
Agents: www.birdphoto.fi, www.leuku.fi, www.agami.nl, www.blickwinkel.de, www.photoshot.com
Canon EOS-1D Mark III + 70–200mm f2.8 lens; 1/2000 sec at f10; ISO 800; angled viewfinder + Finnature ground pod.

**Week 51**
**Snow pounce**
**Richard Peters**
UK
richard@richardpeters.co.uk
www.richardpeters.co.uk
Nikon D7000 + 600mm lens; 1/500 sec at f8; ISO 400.

**Week 28**
**Pester power**
**Mateusz Piesiak**
Poland
matipiesiak@tlen.pl
www.mateuszpiesiak.pl
Canon EOS 40D + 400mm f5.6 lens; 1/800 sec at f5.6 (-1.3 e/v); ISO 400.

**Week 42**
Rock art
**Verena Popp-Hackner**
Austria
office@popphackner.com
www.popphackner.com
Toyo Field 45 AII + Schneider 75mm f5.6 lens; 8 sec at f45; Fujichrome Velvia 50.

**Week 31**
Sunset moment
**Olivier Puccia**
France
olivierpuccia@gmail.com
Canon EOS 5D Mark II + EF 16-35mm f2.8 lens; 1/160 sec at f3.5; ISO 200.

**Week 38**
The warning
**Gaurav Ramnarayanan**
India
gaurav10298@yahoo.co.in
www.thewildside.in
Nikon D300s + 300mm f2.8 VR lens + TC-17E II 1.7x teleconverter at 500mm; 1/800 sec at f9 (-0.3 e/v); ISO 400; tripod + Benro ballhead.

**Week 37**
Tern style
**Ilkka Räsänen**
Finland
ilkkao.rasanen@pp.inet.fi
Nikon D700 + AF-S 300mm f2.8 lens; 1/5000 sec at f5.6; ISO 2500.

**Week 8**
Bottom view
**Michel Roggo**
Switzerland
info@roggo.ch
www.roggo.ch
Agent: www.naturepl.com
Canon EOS 5D Mark II + EF 16-35mm f2.8 lens; 1/85 sec at f5.6; ISO 400; Hugyfot housing.

**Week 30**
The eye of the baitball
**Cristobal Serrano**
Spain
info@cristobalserrano.com
www.cristobalserrano.com
Canon EOS 5D Mark II + 8-15mm f4 lens; 1/125 sec at f4.5; ISO 100; Seacam housing; strobes.

**Week 53**
Where petrels dare
**Mark Tatchell**
UK
mark.tatchell@gmail.com
www.marktatchell.com
Canon EOS 30D + 100-400mm f4.5-5.6 lens at 400mm; 1/1250 sec at f10; ISO 400.

**Week 35**
City gull
**Eve Tucker**
UK
ejtholmwood@googlemail.com
Canon EOS 450D + 100mm f2.8 lens; 1/250 sec at f4.5; ISO 200.

**Week 52**
Frozen in flight
**Jamie Unwin**
UK
jamie@brook-furlong.co.uk
www.jamieunwin.com
Sony A350 + Sigma 18-125mm f3.5-5.6 lens; 1/4000 sec at f9; ISO 400; Minolta 5600HS flash.

**Week 24**
Leaping lemur
**Heinrich van den Berg**
South Africa
heinrich@hphpublishing.co.za
www.heinrichvandenberg.com
Canon EOS 5D Mark II + 16-35mm lens; 1/12 sec at f9; ISO 100; two Quantum flashes.

**Week 43**
Dawn call
**Pierre Vernay**
France
vernay92@free.fr
www.pierre-vernay.com
Nikon D3 + 500mm f4 lens; 1/640 sec at f6.3; ISO 800.

**Week 39**
Last look
**Steve Winter**
USA
stevewinterphoto@mac.com
www.stevewinterphoto.com
Agent: www.nationalgeographicstock.com
Canon EOS Rebel T1i + 10-22mm f3.5-4.5 lens; 1/200 sec at f16; ISO 400; three Nikon flashes; Trailmaster infrared remote trigger.

**Week 10**
The big four
**Tony Wu**
USA
tony@tony-wu.com
www.tonywublog.com
Canon EOS 5D Mark II + 15mm f2.8 fisheye lens; 1/400 sec at f4.5; ISO 200; Zillion housing.

---

First published by the Natural History Museum, Cromwell Road, London SW7 5BD.
© The Trustees of the Natural History Museum, London 2015. All Rights Reserved.
Photographs © the individual photographers.
Text based on original captions used in the Wildlife Photographer of the Year exhibitions.
ISBN: 978 0 565 09361 7
All rights reserved. No part of this publication may be transmitted in any form or by any means without prior permission of the publisher.
A catalogue record for this book is available from the British Library.
Printed in China by Toppan Leefung Printing Limited.